Encaustic Art

How to paint with wax

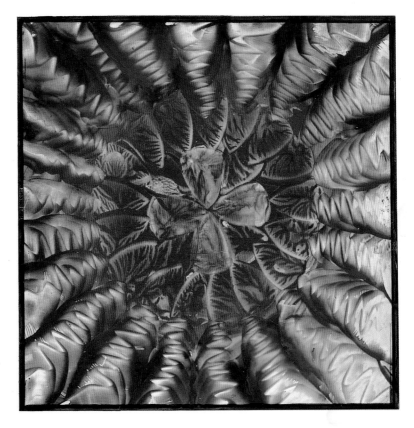

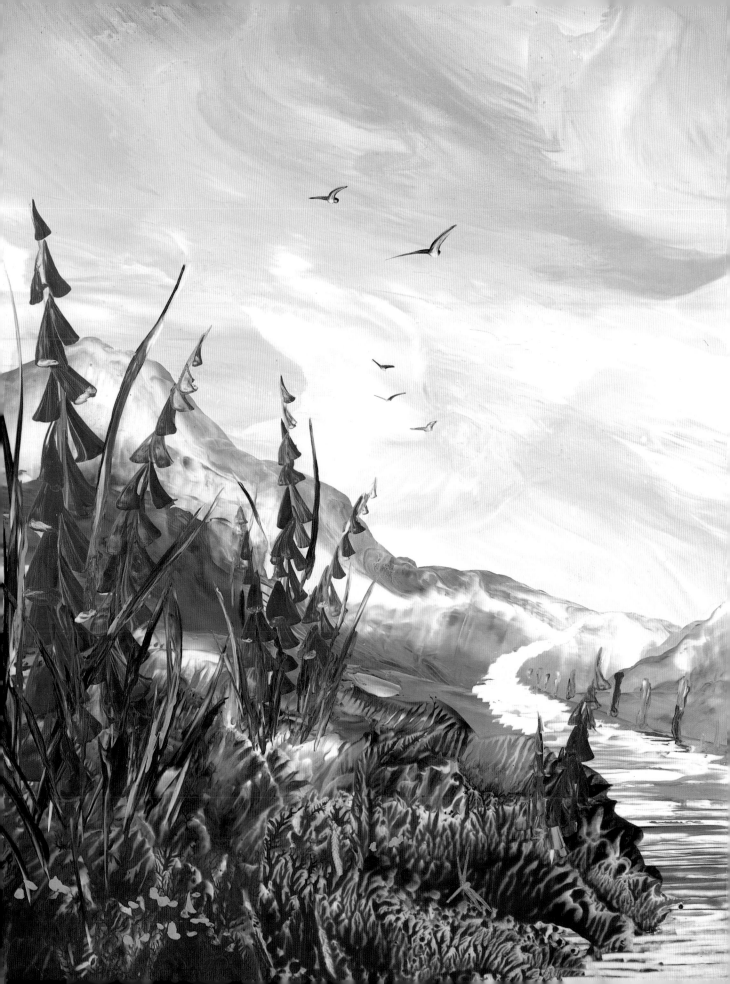

Encaustic Art
How to paint with wax

MICHAEL BOSSOM

Search Press

First published in Great Britain 1997
Search Press Limited
Wellwood, North Farm Road,
Tunbridge Wells, Kent TN2 3DR

Reprinted 1997, 1999, 2000, 2002, 2003, 2005, 2007, 2008
Copyright © Michael Bossom 1997

Photographs by Search Press Studios
Photographs and design copyright © Search Press Ltd. 1997

ISBN: 978 0 85532 826 9

Suppliers
If you have any difficulty in obtaining any of the materials and equipment
mentioned in this book, then please visit the Search Press website for
details of suppliers: www.searchpress.com

Contents

Introduction

Historians claim that the art of encaustic wax painting is at least 2,500 years old and that it was practised by the Ancient Greeks, Romans and Egyptians. It is recognised as being a very durable art form, sometimes lasting even 2,000 years! In museums around the world there are certainly many portraits from those times which are painted on wood. True encaustic painting is a process in which coloured wax is permanently 'burned' into an absorbant backing such as plaster, canvas and some woods. However, the technique of laying wax on a non-absorbant backing is today generally thought of as encaustic art.

The beauty of using molten wax is that whenever the iron touches it, the wax colour melts and can be re-worked. So, you can continue to change your artwork until you are happy with the final result.

Encaustic art is exciting . . . it is fun . . . and it is very addictive. Everyone can do it, but as in all things creative, the most difficult thing is getting started. *Encaustic Art* will show you exactly how and where to begin and you will find that as you become familiar with the basic techniques, you will soon progress from making simple greetings cards to creating much more structured and accomplished artwork.

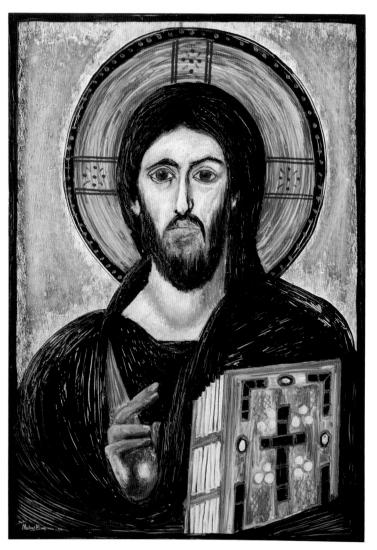

The icon is based on a 6th century image of Christ painted in wax on a wooden base. This copy was painted on to card using a low-heat stylus. The ancients may have used charcoal to heat their waxes.

Opposite:
The rich wax effects produced by the iron can be left as a pattern or developed into fantasy art. Alternatively, use your imagination to transform simple shapes and structures into wonderful landscapes.

Tools & materials

To get started, you need a small electric iron with a low-heat setting, some wax paint and a sheet of non-absorbent card. Melt the wax on the base of the iron, then spread the wax on to the card – you will be amazed at the effects that seem to happen almost by accident! Even if you have no previous artistic experience, you will be able to produce impressive artwork. As you become more addicted, you can add different types of tools to your workbox to create exciting effects.

Tools

Encaustic waxes melt at 60–75°C (140–170°F). Heated tools for direct working of wax must therefore operate at a low temperature because if they are too hot the wax becomes watery, difficult to control, and it may also fume or smoke. If you find this happening, turn the heat down. Work in a ventilated area rather than in a small enclosed space, as some light wax fumes may build up during long sessions.

Painting iron
The basic tool is a small iron, capable of maintaining a steady low-heat of about 70–90°C (158–194°F). Ideally, choose one of the special painting irons that are available as these have good thermostatic control. When inverted, they also double as a heated palette which is useful for more advanced techniques.

Alternatively, use a good quality travel iron and set it at the low or nylon setting. Do not use steam irons as these have holes in the baseplate which will block up and stop you getting smooth effects. A polished metal base is much better than a coated one. Large dry irons can be used, but on small scale work, they can be awkward to manoeuvre.

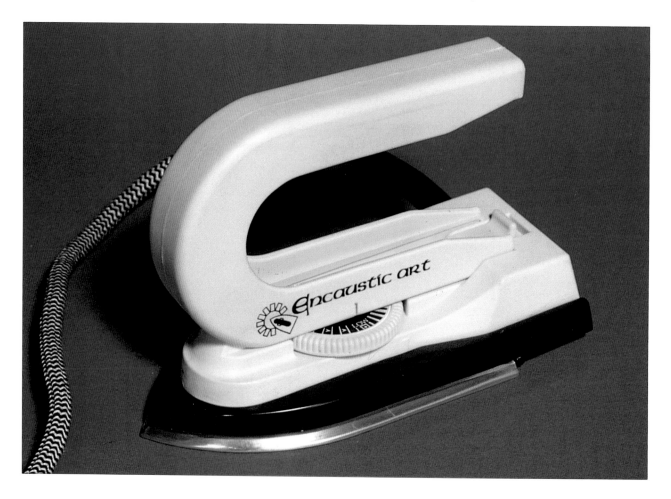

Stylus

A stylus is a heated tool that is very similar to a soldering iron but does not get nearly so hot. Again, these are specially produced for wax painting and operate at a controlled temperature. There are a variety of working tips you can use with them, and you can even make your own for specific jobs if necessary. The most common tips enable the stylus to be used as a pen, a stiff brush or as a palette knife shaped like a mini iron. Ordinary soldering irons are too hot and dangerous to be used safely.

Mini-iron palette knife tips.

Brush tip.

Pointed (pen) tip.

Pencil and marker pen

A pencil and marker pen can be used to trace silhouettes.

Scriber or scratch tools

Sgraffito in wax is a technique which involves the top layer of wax being scratched or scraped away to reveal the colours underneath or the card itself. It is a very effective way of adding detail. Any sharpened item can be used for this technique but the two most popular shapes are a point and a narrow blade. Specific tools with a point on one end and a blade on the other are readily available.

Wax

For their paintings, the Ancients used a mixture of beeswax and natural resins combined with earth pigments. Since then, many technical advances have been made, and today there are several ranges of specialised encaustic waxes available. Do not be tempted to try and make your own. Candles will not work, children's crayons are very poor, and mixing beeswax and pigment is a specialised process. Buy quality materials as these will result in more predictable control. Explore the different waxes and their wide range of colours and handling characteristics.

For a good starter palette I suggest using the eight colours shown opposite. You can expand your colour range by adding the second set of eight waxes which includes clear wax medium for thinning/weakening colours. Of course, there are many colours available, and these can be added as and when opportunities for their use emerge.

Molten waxes mix just like paints, so there is almost no limit to the range of colours that can be produced. Mix small quantities on a card palette or work directly on the base of the iron using a card spatula as a mixing tool.

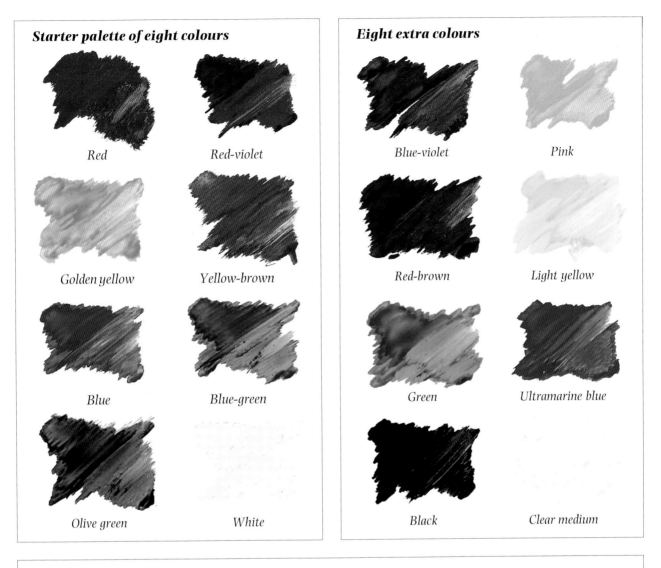

Starter palette of eight colours

Red

Red-violet

Golden yellow

Yellow-brown

Blue

Blue-green

Olive green

White

Eight extra colours

Blue-violet

Pink

Red-brown

Light yellow

Green

Ultramarine blue

Black

Clear medium

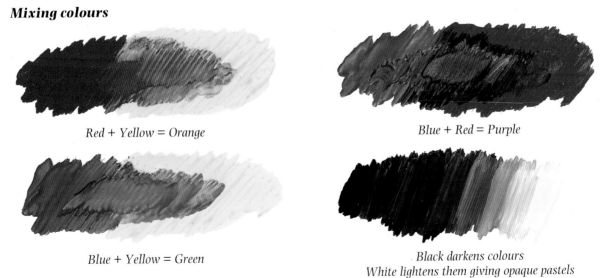

Mixing colours

Red + Yellow = Orange

Blue + Red = Purple

Blue + Yellow = Green

Black darkens colours
White lightens them giving opaque pastels

Wax can be applied to a variety of different surfaces.

Painting card

Wood, glass, metal, composite boards, fabrics (from silk to aida canvas), absorbent paper and card, shiny coloured paper and card – the list is endless – can be worked on with wax in some way or other. However, for long-term pieces, encaustic art is best worked on a good quality non-absorbent card, either coated or with a gloss or matt finish. As the colour sits on the surface, these types of card do not absorb much pigment – so, in effect, the card does not get dirty and, therefore, you can make repeated changes. In this book, unless otherwise specified, the word 'card' always means non-absorbent card.

A thick coating of wax on a flexible card can crack if it is flexed too much, so, for long-term protection, keep these pieces flat or fix them on to rigid backings.

Opposite:
Greetings cards are fun, and they are a great way of sharing your creative talents with family and friends.

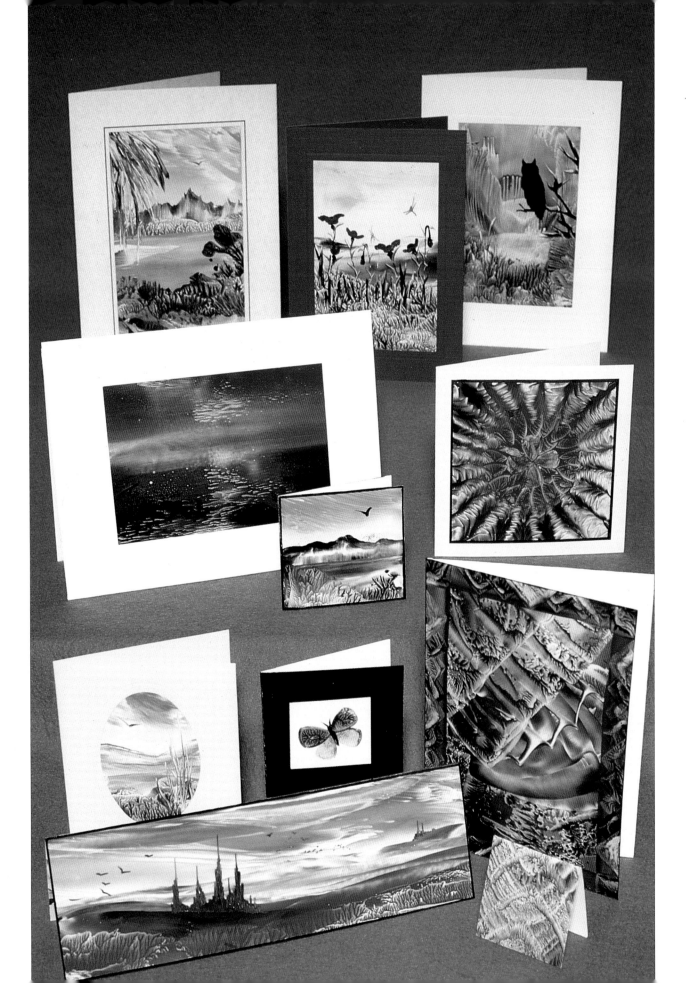

Basic techniques

In this chapter I introduce the four basic actions: smoothing, dabbing, side or edge marking, and working with the point of the iron. I explain how to combine them into a colourful abstract picture and then I show you how to develop them into a simple structured landscape.

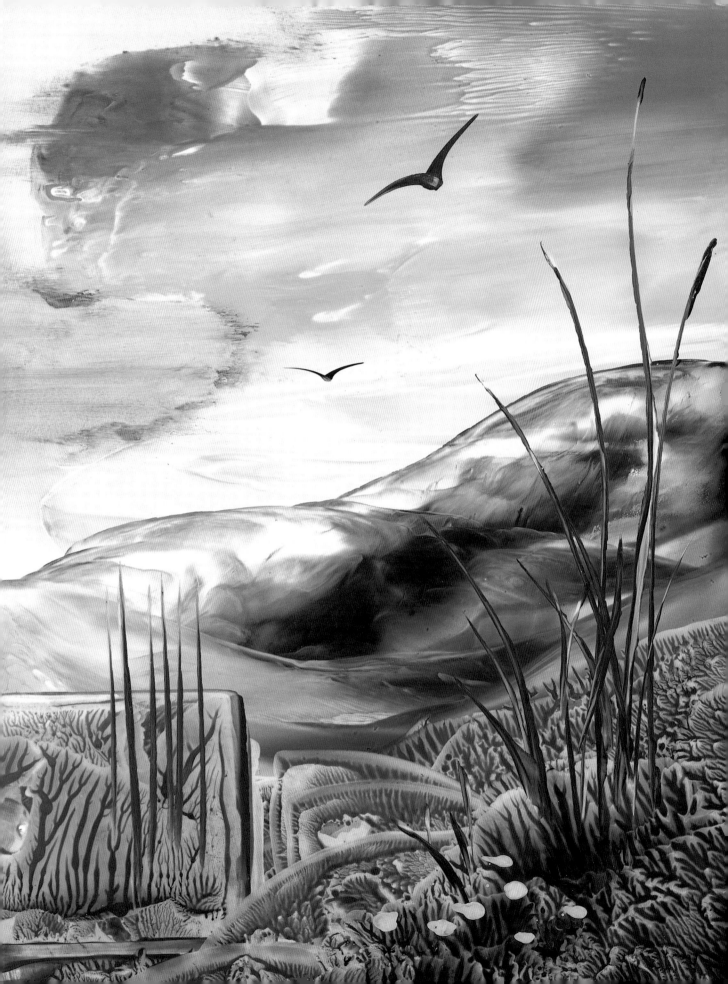

Getting ready to start

Before getting down to putting wax on paper, get your working area organised and then get used to loading and cleaning the iron.

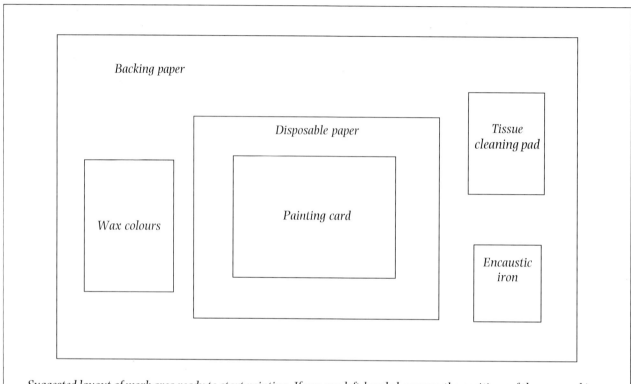

Suggested layout of work area ready to start painting. If you are left-handed, reverse the positions of the wax and iron.

Organising your work area

Ideally you need a flat table top about 750 x 450mm (30 x 18in). Protect the surface with a pad of flat newspaper or a sheet of hard card (mountboard or strawboard is fine) and cover this with a large sheet of clean paper – newsprint or old computer paper are ideal. Fold up another sheet of clean paper to about twice the size of your painting card, and place this on top – this piece of paper will get dirty and must be changed regularly.

Stand the encaustic iron to one side of the disposable paper (to the right if you are right-handed). To give yourself freedom of movement, I suggest that you use an extension lead to connect the iron to a power source. Switch on the iron and set the thermostat to the lowest heat which is normally marked 'low' or 'nylon'.

You will need a good supply of tissues for cleaning the iron. Try using high quality two-ply tissues as these are strong and absorbent but still soft enough for polishing the finished wax artwork. Place a small pad of folded tissue near the iron.

Lay out your selection of coloured waxes on the other side of the painting area.

Finally, place a piece of painting card on top of the disposable paper. You are now ready to start painting.

Loading and cleaning the iron

Before starting to create images get used to holding the iron, loading it with wax and then cleaning it off.

Loading the iron

Hold the iron upside down with its baseplate horizontal – if it is tilted, wax can dribble off. Rub a wax block on the baseplate; it should melt to a thick oil consistency and, when the baseplate is turned to a vertical position, the wax should slowly dribble down. If the wax does not melt immediately, slightly increase the temperature, but do not go too far or the wax will be too watery and run off the iron. When you are happy with the wax consistency, clean the iron and then practise the basic techniques.

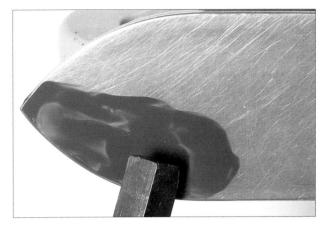

Rough cleaning the iron

Clean the iron regularly. A rough clean, by simply wiping the baseplate of the iron across the tissue pad (see right), will be sufficient for normal work.

Thorough cleaning

When changing from dark colours to lighter ones, or when working pale-coloured skies, you should thoroughly clean off all traces of colour pigment as shown below. Pay particular attention to cleaning the wax from between the baseplate and the body.

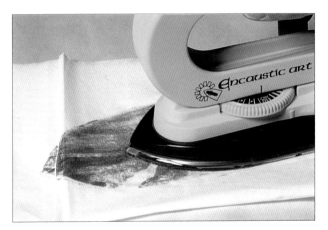

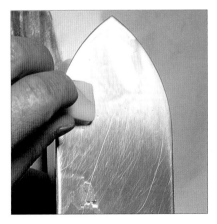

1. Melt clear wax medium, or an old candle, on the baseplate to dilute remaining colour pigment.

2. Fold a sheet of tissue into a pad and polish the baseplate to remove all traces of wax.

3. Fold the tissue again, crease it to form a sharp edge and then clean the edges. Add more clear wax as necessary.

Practising the techniques

Now try out the following four techniques. Practise them a few times until you feel you have some control over the results.

Smoothing

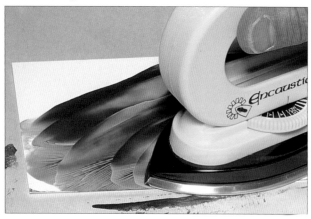

This technique gives a smooth and even coat of wax. Instead of pressing down hard as you would if ironing normally, glide the waxed iron lightly over the card, almost as if it were floating. Get used to the feel of this action and notice the type of marking produced by the wax.

Dabbing

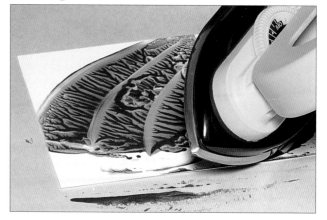

This action creates the veining effect so characteristic of encaustic art. To achieve this, simply dab a loaded iron on and off the card. As you pull the iron off, air rushes into the space, thereby forcing the wax aside into the series of connected streams. The speed of this action affects the result.

Side or edge markings

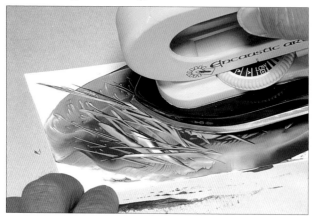

The side of the iron is used to create white lines on a waxed card and to add detail. Use the smoothing technique to cover a piece of card with wax. Then, hold the iron so that the rounded edge of the baseplate sits on the wax like an ice-skate or knife blade, and gently push it across the wax to make a thin white line. If you twist the edge of iron as you slide it across the card you will create broader lines.

Working with the point

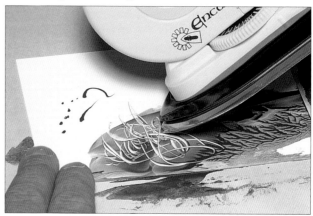

The most refined part of the iron is its point, which you can use to make very fine lines. You can also dip the tip of the iron into a block of wax, pick up some colour and then draw with it. It is not the greatest of drawing tools but it can be used for some detail work to great effect.

A simple abstract

When you have explored the potential of the four basic techniques, it is time to dive into the world of creativity. For this project, you can combine the techniques you've already tried to form a simple, single-colour abstract composition.

First, use the smoothing technique to cover a card with a single colour. If there is not enough wax on the iron to cover all the card, just load some more wax on to the iron and add it into the existing layer.

Now experiment with combinations of iron strokes and watch how the patterns change with each stroke.

When the wax is cool, lightly polish it with soft tissue. Rub back and forth in one direction until an even shine has been achieved. Too much pressure will remove some of the colour, so be gentle.

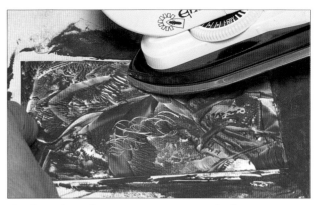

Combine the techniques to create a simple abstract.

Use a soft tissue pad to polish the wax.

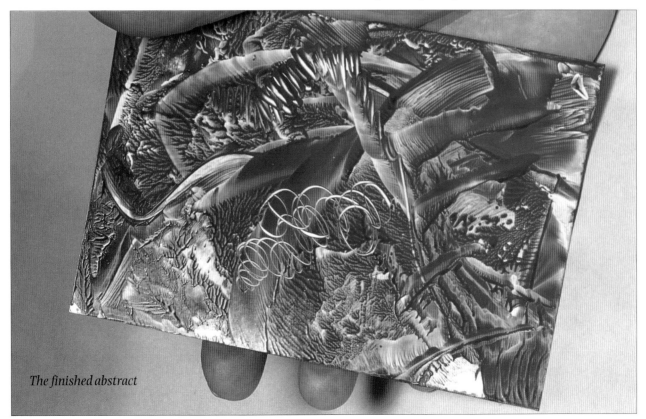

The finished abstract

A structured landscape

When you are used to making shapes with the iron, try out a simple monochrome landscape. Use the smoothing technique to create a horizon and distant hills; the dabbing action to create foliage in the foreground; the side of the iron to add some grasses; and the tip of the iron to draw a bird.

1. Melt a good coating of wax on to the lower half of the baseplate and its outer edge. (Mirror the image if you are left handed.) You want to work down the card so, when the iron is turned over, the wax must be on the top half of the baseplate.

2. Position the iron parallel to the long edge of the card, with its point at the middle of a short edge, and gently slide the iron backwards to leave a single application of wax on the card.

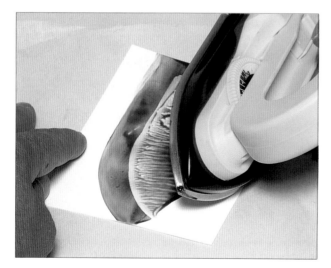

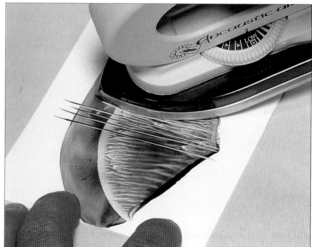

3. Hold the top of the card down, place the iron on to the lower half of the spread wax and immediately raise the top edge of the iron off the card (pivot it on its lower edge). If the result is dry and scratchy add more wax and repeat the action.

4. Looking down on the iron, gently rest its inner curved edge on the bottom of the card, about three quarters of the way along. Slowly push the iron forward, cutting a line through the wax. Repeat this action several times.

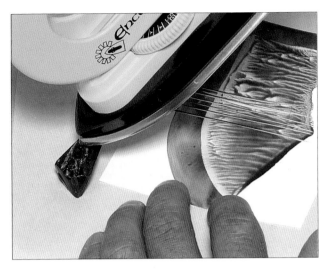 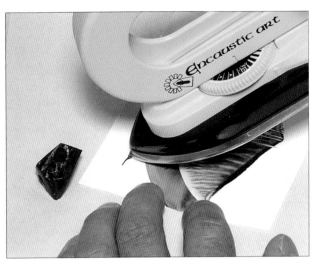

5. Clean off excess wax from the baseplate of the iron with tissue and then take up a spot of wax on the tip of the iron by touching the point against a block of wax colour.

6. Touch the tip of the iron on to the blank sky area to leave a spot of wax. Clean the iron again, place the tip of it back on the spot and then swiftly flick it to the left and slightly upwards. Now make another flick to the right to complete the image.

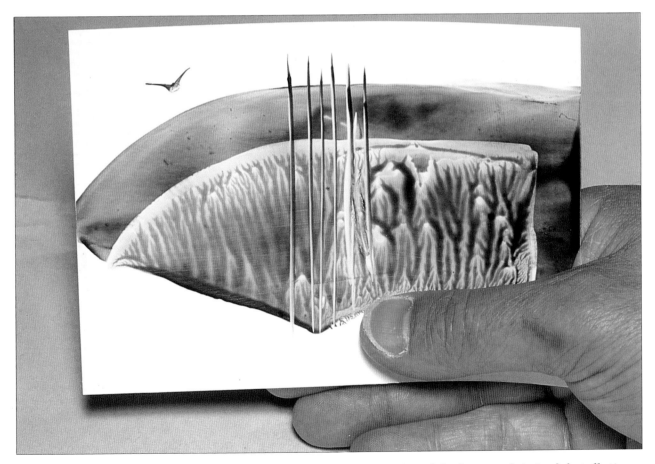

The finished landscape. Notice the three basic areas: the sky, the distant hills and the foreground. A simple but effective structure which, although elementary, makes an effective picture.

Developing your technique

Basic techniques can now be refined into a variety of more controlled strokes and actions. You can enter the world of fantasy, where chaos becomes ordered as you develop patterns, create borders, and explore working with backgrounds.

Hand-held dabbing

When dabbing on a flat surface you will have found that you always get the shape of the baseplate on the wax. This exercise shows you an alternative dabbing technique which eliminates this problem. If you try not to let the top edge of the iron touch the card, you will get a more natural free-form effect. Choose two colours that work well together and which, when mixed, produce another effective colour.

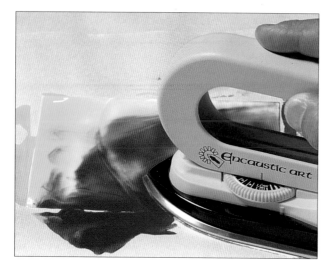

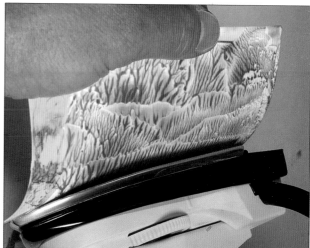

1. First, use the basic smoothing technique to lay down two colours. Keep the colours in separate areas of the card to avoid over-mixing too quickly.

2. Hold the card between two fingers and a thumb of your free hand. Now, hold the iron at an angle to the card and spring it on and off the wax, gently but firmly, allowing the card to bend slightly. Do not let the top edge of the iron contact the card.

The finished card. Note the difference between the image created by hand-held dabbing, and the one you get with ordinary flat dabbing (inset).

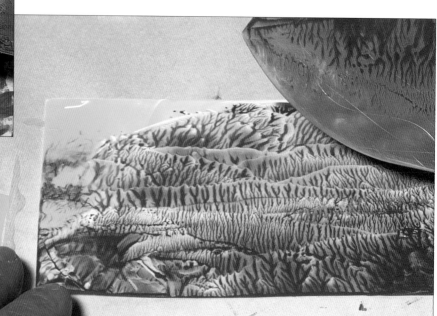

Straight lining

You have already used the side of the iron to add grasses to a simple landscape, but you can also use it to get other, more striking, effects. In this exercise I show you how to draw different thicknesses of lines.

 Create a background and then clean all wax from the iron. Place the iron so that its straight edge is on the work surface. Push the iron forward along this edge through the wax. If you keep the iron steady, you will draw a fine line.

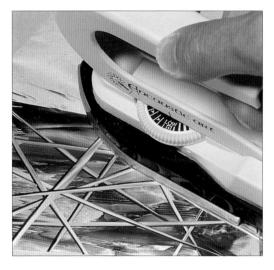

Draw straight lines with the straight edge of the baseplate, turning the card between each stroke. Try skewing the edge of the iron as you push it along, and note how the line gets wider. This action can be difficult to control; you may get a little wobble over the length of the line. Again, do not worry as these wobbles can be used to good effect.

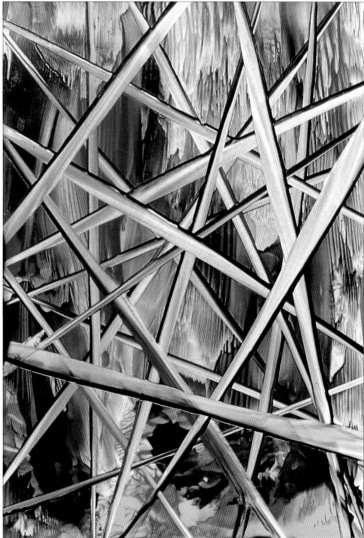

Build up lots of lines on the card, rotating the card between strokes so that the lines criss-cross all over to give a geometric abstract.

Freehand drawing

Develop your freehand drawing skills by scribbling firstly with the clean point of the iron, and then with some colour loaded on the tip. If you practise this exercise, you will find it easier to add detail later on.

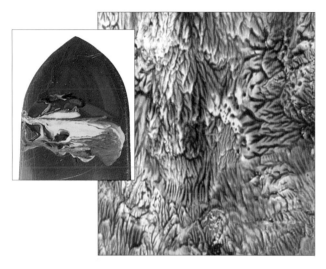

1. Load the iron with a number of colours, let them run into each other, and then, using the smoothing and dabbing techniques, make a multi-coloured background.

2. Now clean the iron and use the point of it to scribble and draw unending lines and designs into the background. Use relaxed small and large circular movements or, perhaps, figures of eight.

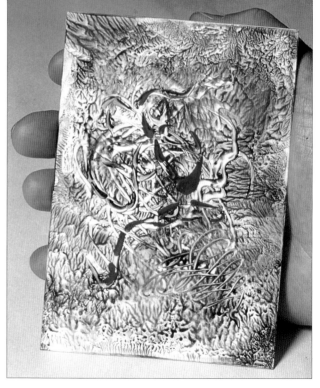

3. Next, dip the point of the iron into a colour and apply this in a short stroke on top of the existing design. To make it easy, follow the shape of one of the existing lines.

The finished abstract.

Approaches to abstract

There are unlimited possibilities for abstract images. They are a good way to start exploring your own imagination and creativity. Here are three approaches to abstract that will help develop your control and technique.

Chaotic abstract

As its name implies, this approach has neither visible repeated patterns, nor a structured and planned design. It is merely an interesting and effective use of random colour – try different sets of colours.

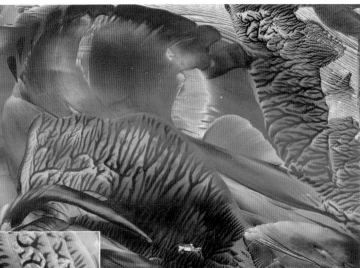

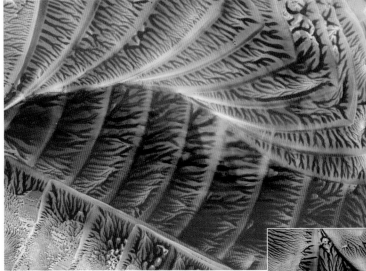

Rhythmic pattern

Move the iron across a waxed card, repeating a stroke with it as you go. You will find that the result is a pattern of similar marks in a rhythmic style. Footsteps on the beach are an example of this technique. See how many different rhythmic patterns you can make.

Reflected pattern

Repetition of a shape creates a simple form of pattern. To develop this, you need to add structure, and one of the simplest ways of doing this is to create a mirror image. Cover a card with wax and create a design on one half; now try to mirror the design on the other half. If you place the edge of a mirror along the middle of the card you will see an exact reflection of the pattern. How close can you get to a perfectly reflected pattern?

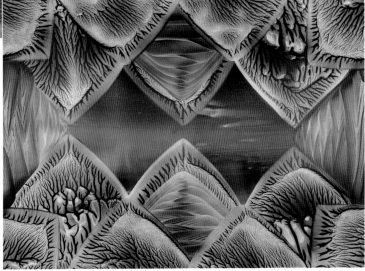

Abstract borders

Presentation of your work is important and you will find that a border can really enhance your picture. On the opposite page I have included a few pictures that I have finished with a variety of borders. Here is a simple one for you to try.

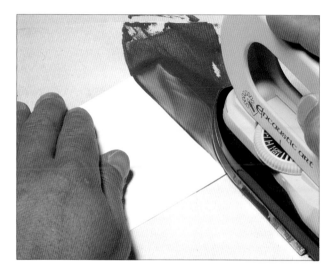

1. Load the iron with a single colour and use the smoothing technique to draw a line about 20mm (³⁄₄in) wide down one short edge. A straight-edged rule will help you keep lines square to the edge of the card.

2. Turn the card through 90° and draw another line down the long edge. Repeat to form a complete border.

3. Now make rhythmic patterns on this band of wax with the flat point of the iron.

4. Load a second colour on to the pointed end of the iron and then repeat the rhythmic pattern all round to form a two-colour border.

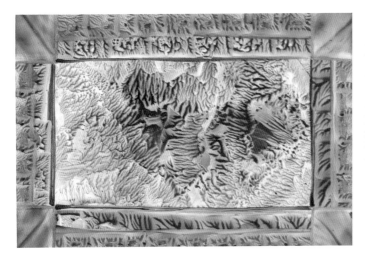

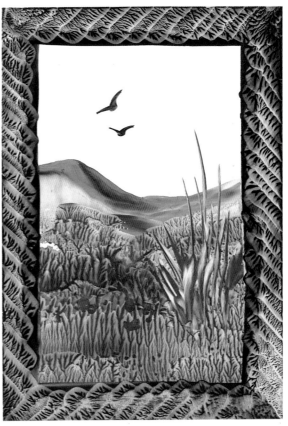

These borders add a further creative touch to the artwork. Try using one background colour and decorate it with another toning one. Experiment by adding designs with the scribing tool. You can use the waxes as crayons too. Just crayon over any existing wax areas or places where you have scraped colour away. Include stylus work with bright metallic waxes and decorate with triangles, squares, circles, dots, squiggles, lines or hatching – in fact anything that you find attractive.

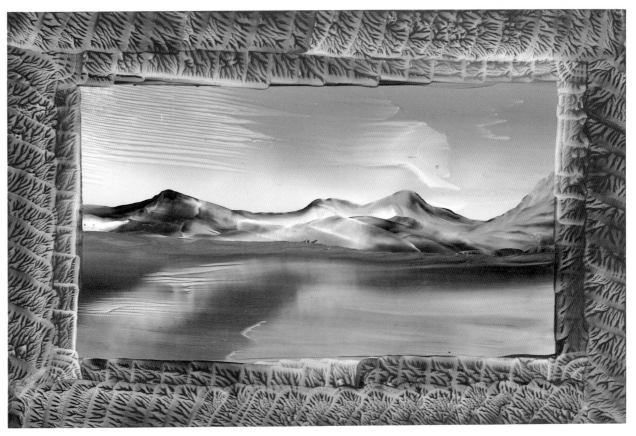

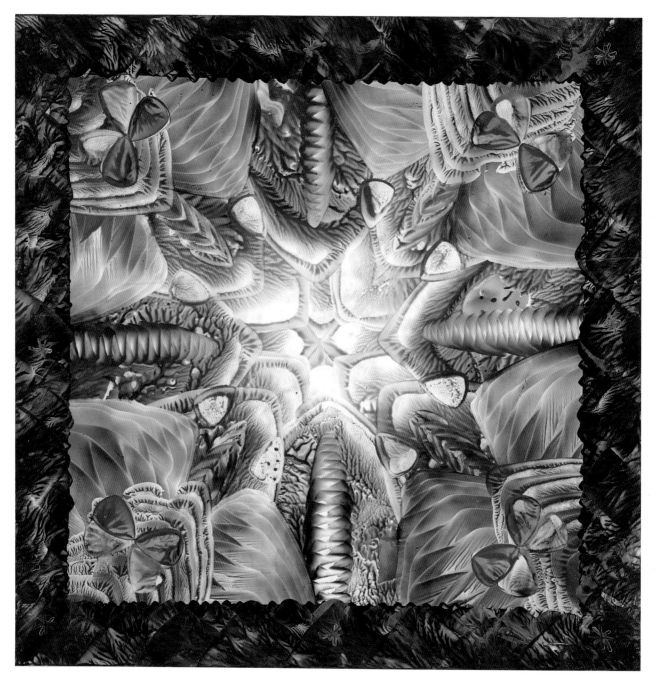

Mandala

A mandala is a structured abstract which consists of a collection of balanced patterns, expanded rhythms and developed forms. The patterns begin in the centre and grow outwards constantly reflecting each other, so the effect is kaleidoscopic. Mandalas are best worked on squares rather than rectangles, and I suggest you start with a 150mm (6in) square.

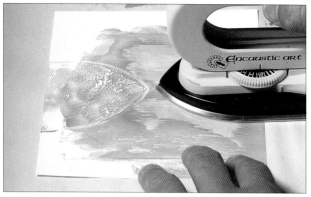

1. Create a single-colour background in the middle of the card. When dry, scratch a small cross in the exact centre of the wax.

2. Place the iron square to the edge of the card with its point touching the centre point. Lift it off the wax and repeat the image on all four sides.

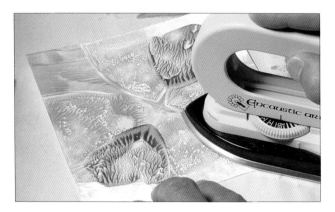

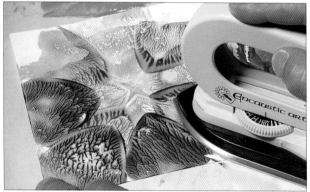

3. Load a green wax on the iron and dab on four images. Work on the diagonals of the card and place the iron's point 25mm (1in) from the middle.

4. Load the iron with a dark blue wax and add a further eight dabbed images with the points about 50mm (2in) out from the centre point.

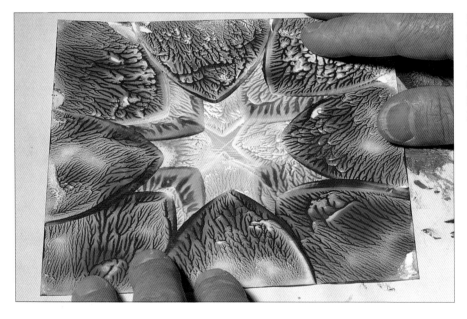

The finished mandala. On bigger cards build up more layers of reflected patterns. Although a very structured approach, it is still wonderfully creative and there are limitless possibilities for the mandala form.

Realistic landscapes

We all accept that the sky is blue and that leaves are green. But, the sky is not always blue and leaves can range from pale yellow to bright green, rich red or dark brown. Observation is the key element in producing a realistic landscape. Look carefully at the scene. Is the horizon line flat, gently curved or jagged? Are the trees rounded or column-like? Is there foreground detail that can be included?

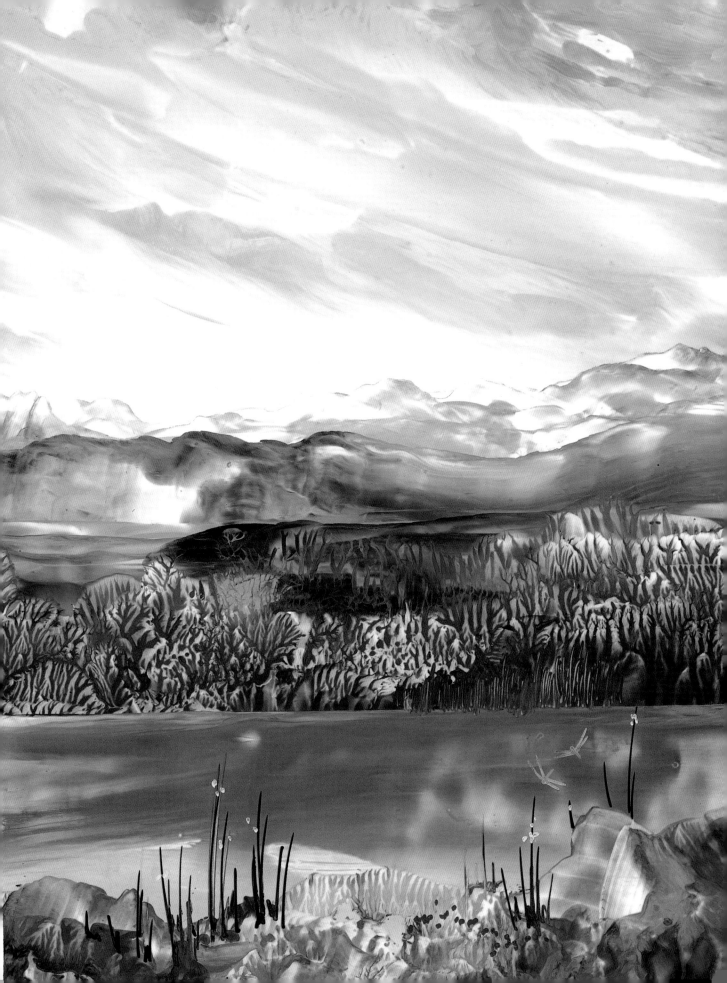

A natural landscape, step by step

Improving on the simple landscape shown on pages 20–21 is not difficult.
Using more realistic colours and variations on the basic iron actions will make
a big difference to your picture.

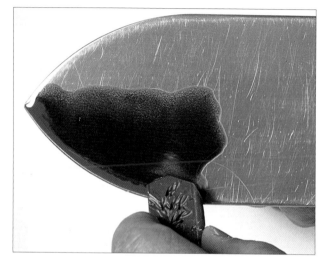

1. Melt a generous amount of green on to the base of the iron and then add a stripe of yellow-brown along the edge. Keep the iron flat to avoid dribbles.

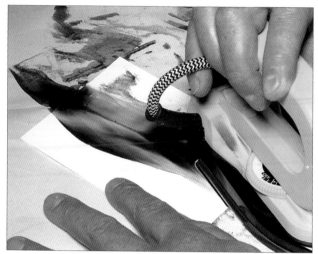

2. Hold the top of the card and place the iron at the right-hand side about one third of the way down. Lightly smooth the iron right across the card to create a solid, flowing horizon line. Do not lift the iron.

3. Now gently smooth the iron back across the card, keeping its top edge well down from the previous stroke. Continue to zig-zag down to the bottom of the card, adding more wax if necessary.

4. Pick up the card and use the hand-held dabbing technique (see page 24) to create foliage along the bottom third of the card. If the effects are weak, add more colour to the iron.

5. Now use the edge of the iron to add some grasses to the foreground. Vary the length and thickness of the lines and take some of them above the horizon line into the sky area.

6. Dip the tip of the iron into a dark colour and make small dots in the sky. Clean the tip and then use it to flick the colour from left to right to form the flattened V-shapes of birds in flight. Finally, use the same action with brightly coloured spots to add flowers to the upper area of foliage.

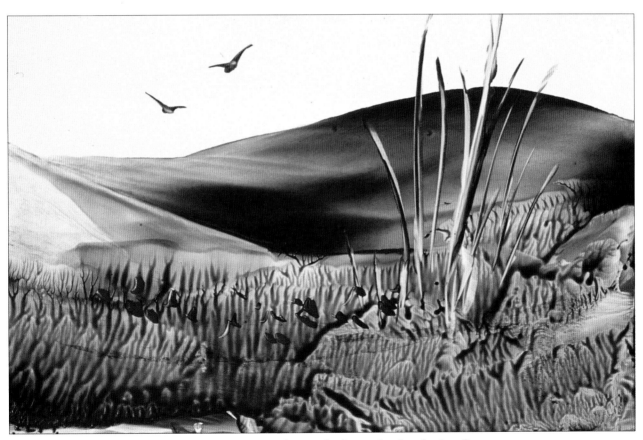

The realism of this landscape is achieved by the use of natural colours, the clear horizon line, the absence of edge marks in the foliage, and the irregular shapes in the foreground grasses.

Four basic horizons

Next, develop different types of horizon. The shape of the horizon tells you about the type of landscape in the picture. You can vary your landscape dramatically by using one of four basic forms of horizon.

Flat horizon

Plateaux, plains, calm water on lakes and, of course, the sea, all have flat horizons. To create the horizon for a flat land mass, load the base of the iron with a natural green and then run a block of yellow-brown wax along one edge. Place the iron on the left side of the card and move it slowly across in a straight line until you slide right off the right-hand side on to the underpaper. When depicting water, it is important to keep the line parallel with the top edge of the card.

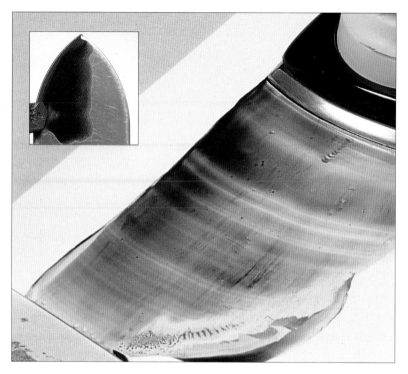

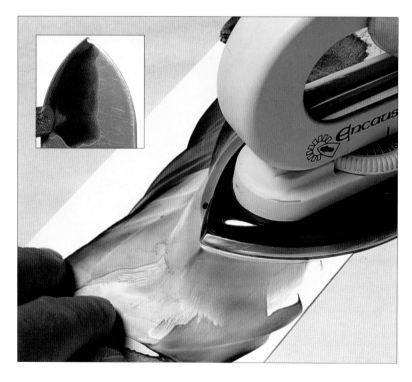

Rounded hills

Rolling countryside can be created using the same type of loading as for the flat horizon. The lines of the rounded hills are formed by the top curved edge of the iron, as shown on page 34. Move the iron along in waves to encourage the rounded forms along the horizon line.

Upland hills and soft mountains

Irregular-shaped horizons give the illusion of being further in the distance. Begin by drawing some rounded highlands.

Load a triangular area of the baseplate, covering about 40mm (1¹/₂in) down each edge. The wax must be fluid when you tilt the iron. If the type of wax that you use is rather thick, add a little clear medium wax to thin it down.

You will be using the tip and the first 25mm (1in) of the curved edge of the iron, so place the tip on the left-hand side of the card allowing a blank band for the sky area above. Keep the back end of the iron about 15mm (¹/₂in) above the card, and do not let the iron base rest flat on it. Now, gently move the iron toward the right, drawing an irregular bumpy line with the tip. If the wax does not flow smoothly, hold the iron at a steeper angle.

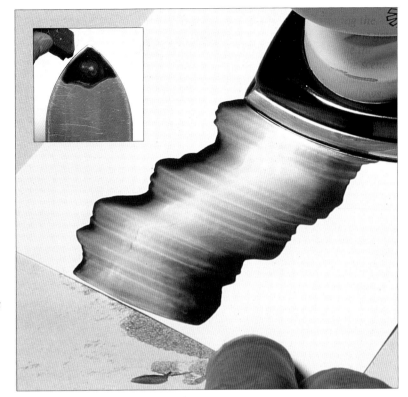

High rocky mountain peaks

Now try sharp mountain peaks. Again, load the iron with a triangular shape of fluid wax. Start on the left-hand side of the card but this time only allow the edge of the iron, not the tip, to rest on the card. This is the grass-making position but, instead of sliding forwards along the edge, push the iron sideways in hesitant, jerky movements, pausing at the high and low points. Try not to saw the iron up and down in a regular pattern as this creates an unnatural look.

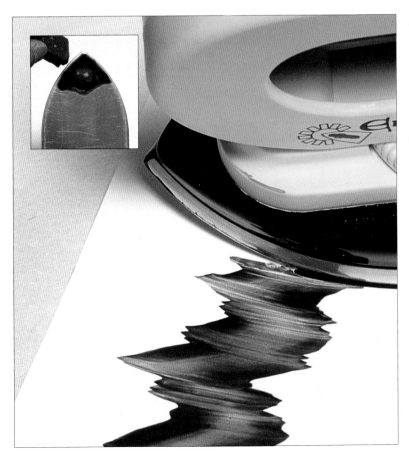

Adding depth to a landscape

Up until now we have restricted detail to drawing grasses, but there is a lot more that you can do to make your landscape realistic. You can add depth to a picture by including things such as fence posts and streams that run from the background to the foreground.

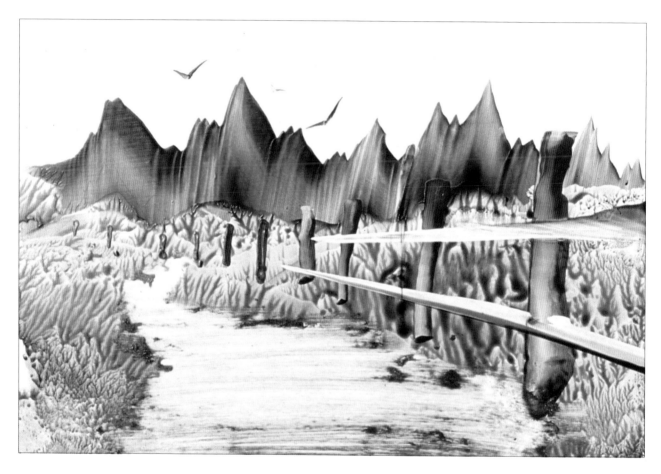

In order to create depth, you need to understand about vanishing points. Draw a spot on a flat horizon and a post standing in the foreground. Join a line from the top of the post to the spot on the horizon and then do the same from the bottom of the post. The spot on the horizon is the vanishing point, and the two lines represent the size of the posts as they recede into the distance.

Posts and fences

1. Load the tip of the iron and apply a spot of wax in the middle distance, where you want the top of a post to be; carefully drag the tip down to form a thick line. Repeat the action to make a number of increasingly larger posts in the foreground.

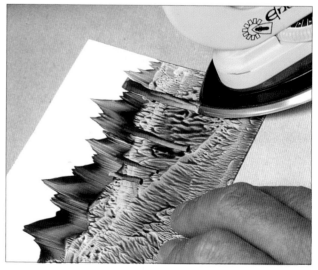

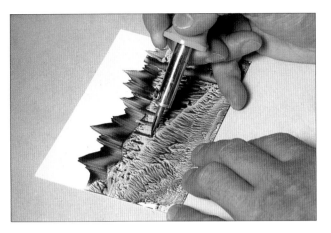

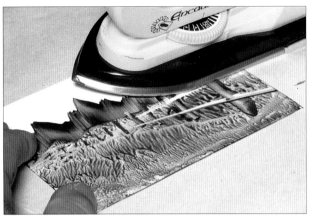

2. For smaller and thinner posts in the distance, use the pointed tool in the heated stylus. The point behaves just like a dipping pen.

3. Now use the side of the iron to draw two lines between the posts, directing each towards the fence's vanishing point.

Pathways and streams

Use a scribing tool for pathways and roads. For streams and rivers, use a tissue point, to give a softer edge. Make this by folding a full tissue into a small pad then twisting it tightly round until a hard point is formed. Instead of making a straight stream put an S-curve into the image, rubbing out colour just as the wax is cooling. Start in the middle distance and work down the card making the stream wider as you go. Make another clean point if the tissue gets too dirty.

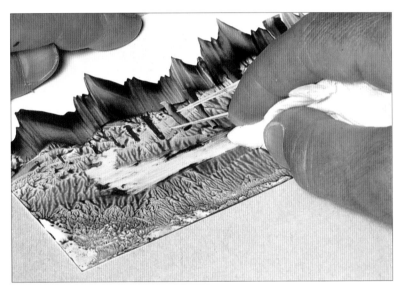

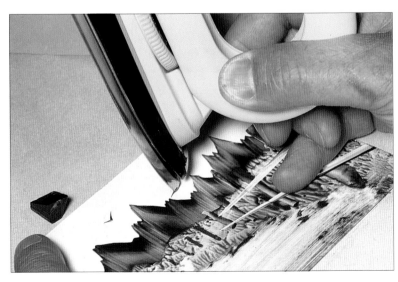

An alternative grip for iron point work

If you find it difficult to work with the iron point in the conventional way, try holding the iron as if it were a huge pen, resting the lower part of your hand on the table. Beware of dirty wax dribbling out from the inside of the iron.

Skies

To add a coloured sky to a landscape, you can either rub a cold wax block on to the card, or apply melted wax with the iron. Choose strong colours – blue and purple are good to start with. For this exercise, you will need to paint an horizon and landscape foreground on to a card, leaving at least one-third blank for the sky.

A rubbed sky

1. Clean and soften an edge of the wax block. Choose a short straight edge, press it hard on some waste paper and start to draw a broad line.

2. As you move across the paper, lift the back edge of the block to form a rounded corner.

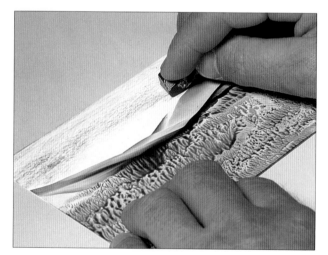

3. Lightly rub an even coat of blue wax on to the top half of the sky area. Add an overlapping band of purple that only meets the horizon at the edges. Leave the middle section blank to draw the eye into the picture. If you add too much wax, remove it by rubbing hard with a tissue over your finger.

4. Blend the two colours by rubbing your finger back and forth across the sky. Rubbing creates heat which softens the wax, helping the colours to blend. You must rub quite hard so hold the card firmly with your other hand – take care not to buckle the card.

Reflecting sky colours in the foreground

Reflected light from the sky is normally said to be white. However, if the sky is coloured then these colours need to be reflected in a landscape to create harmony, and give the impression that the sky and landscape belong in the same picture. For this exercise, scribble a little blue and purple wax on the iron and then dab this into the foreground area so that it blends with the existing green.

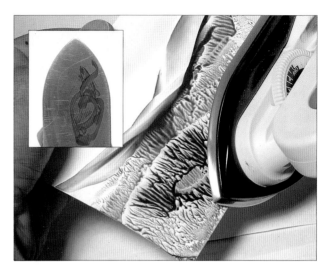

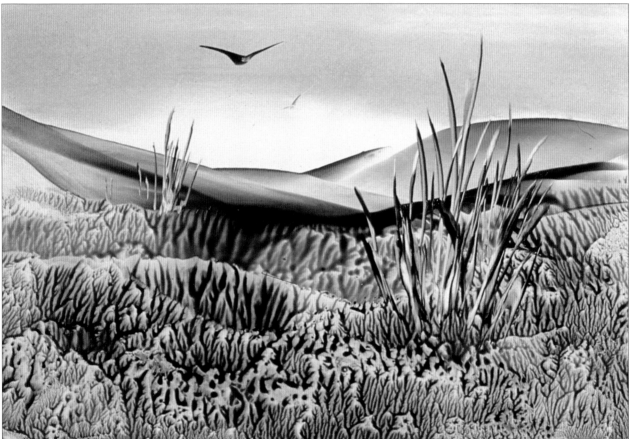

Add extra depth to your picture by repeating elements such as birds and grasses. Remember that big objects appear closer than smaller ones.

Making a sky with the iron

When your sky is made from pastel colours, clean the iron thoroughly (see page 17) to remove all traces of dark colours which could muddy the image. Use blue, pink and white to start with and then try using yellow instead of blue. You can also experiment with clear wax medium instead of white wax. A low viscosity thinning wax will give a flatter, calmer feel to a sky, whilst a high viscosity thickening wax will add texture and body.

2. To create a calm sky, place the iron on the card with its handle at 45° and its tip and curved edge just over-lapping one side. Carefully pull the iron in a smooth continuous action straight across, keeping it parallel with the top of the card.

The colours should blend but remain as separate bands. If they become too mixed, add fresh lighter colours over the existing ones using exactly the same technique.

1. Apply a line of white wax, at an angle of 45°, across the base and spread the wax evenly to fill the entire area up to the tip. The wax must be fairly fluid. Place a stripe of blue wax at the same angle, close to the back of the iron but still within the white wax area. Finally, add a stripe of pink wax leaving an equal band of white at the front of the baseplate.

3. If you want a cloudy, blustery sky, add texture to imply movement and activity. Work back over the wax with slightly curving strokes at oblique angles. Use quick, short strokes and lift the iron off the card as you complete each stroke. This movement requires practise but the technique brings great rewards.

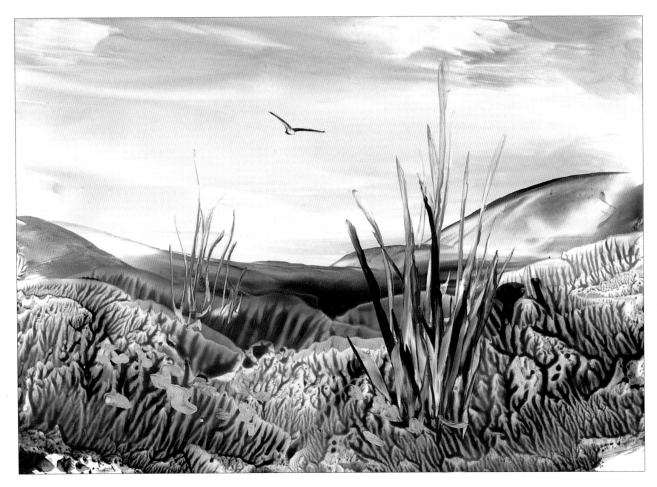

4. Cut through the wax at the base of the sky to add an horizon, and then complete the foreground. Compare this image with that on page 41.

An example of a calm sky. Slow, smooth, horizontal strokes across the card give a soothing, untextured result. Here I have also changed the ratio of the sky to land areas.

Lakes and water

Water is a component of many landscapes. Still water is absolutely flat and has the quality of a mirror; flowing water has surface pattern and direction; and stormy water has turbulent form and movement. Molten wax is also liquid and it therefore offers an interesting resemblance to water.

Wiping off warm wax

The quickest way to create the effect of water is to wipe wax away from the foreground area of a landscape while it is still warm – this is especially effective if you are using a plain white sky. Practise the technique on a card painted with an horizon and a foreground only. Prepare a wiping pad by folding tissue into a 50mm (2in) square. Dab the iron on to the foreground area to get it warm again and place the card flat on the table. Wipe the tissue across the wax with light swift strokes, keeping the tissue parallel to the top edge of the card. This action leaves just a smear of wax to give the impression of shade, reflection and surface pattern. The use of too much pressure or too many strokes will remove all the wax and give a flat effect.

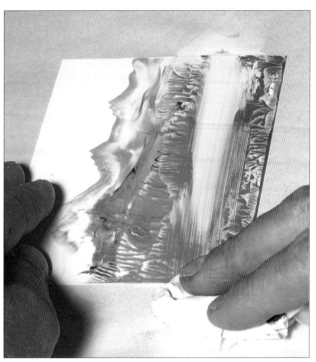

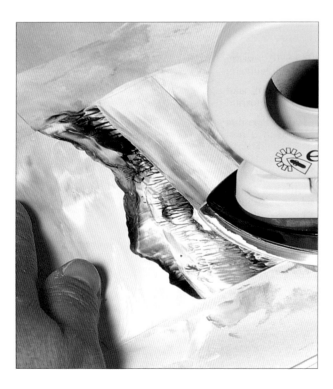

Reflected sky colours

The sky is often reflected in water. To create this effect, paint an upside-down version of the sky where you want the water to be. Start by painting a sky and an horizon, and then add a narrow band of dabbing to represent trees on the far side of the lake. Re-load the iron with the same colour bands as used for the sky and apply these to the bottom of the card (see the technique for creating a calm sky, page 42). Mix some of the darker colour to create shade by trailing the tip of the iron through the bottom of the dabbed trees. If you need to repeat the stroke, start from the farthest point again.

Clear wax medium

Clear wax is very useful when representing water. It provides body, texture, form and surface pattern without adding new colours. Load the iron with clear wax medium instead of the sky colours and lay in the water using the reflected sky method. A low viscosity thinning wax will give a flat, calm feel and a high viscosity thickening wax will add texture and body. Experiment by substituting clear wax in place of white wax for both water or sky techniques as shown in this picture of a sunrise.

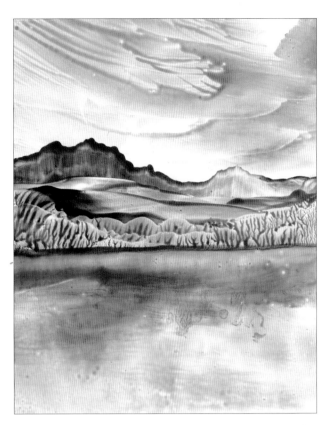

A believable landscape (below)

Here I have created a landscape that combines lots of different techniques. You can experiment with techniques by expanding the basic three-band structure to four, five, six or more bands; overlapping the bands and blending them together; using vertical lines to break across or join horizontal ones.

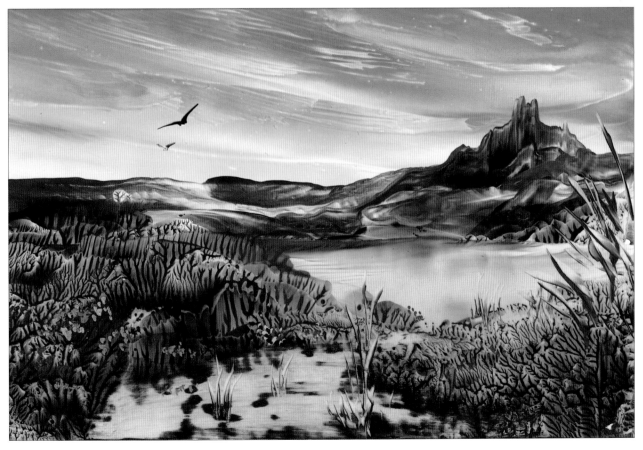

Flowers and trees

Up until now we have restricted detail to very stylised images, but you can also include more realistic items. However, do avoid too much detail. Here I show you how I draw foxgloves with an iron, and trees with a low-heat stylus.

Use the edge of the iron to draw in a stem, and then add a series of bell-shapes on either side of the stem.

Use a scriber tool to pick out small oval areas at the end of some of the triangles to emphasise the bell shape.

Collect a spot of colour on the tip of the iron. Place the tip on a card and flick it forwards to create a small elongated triangular shape. Try making different sizes.

Finish by making foliage around the foxglove with the edge of the iron. Cut leaves across the flowers if necessary.

Create a variety of colours for the leaves by mixing greens with yellows and white on a card palette.

For clusters of tiny leaves, melt some wax on the iron and then use a natural hair brush to dab the wax quickly and lightly on to the card.

Make dots of colour with the stylus for individual leaves.

Make dense areas of leaves with a brush-head fitted to the stylus. Apply a dark green first, clean the brush head with tissue and then work over the wax again to create paler areas on the light side.

Draw in bare branches with the stylus.

Use a yellow-brown wax to draw the structure of the tree, tapering the trunk and branches as you get higher up. Add black to the shadow side of the trunk and the thick branches, and white to the light side. Use a dry tip to blend the colours.

Opposite
Foxglove Path
This picture was painted as one of a series of greetings cards. Depth is created by painting large flowers in the foreground and tiny ones in the middle distance. Notice how the fence and the S-shaped pathway help to create perspective. The overhanging tree is very basic in its structure.

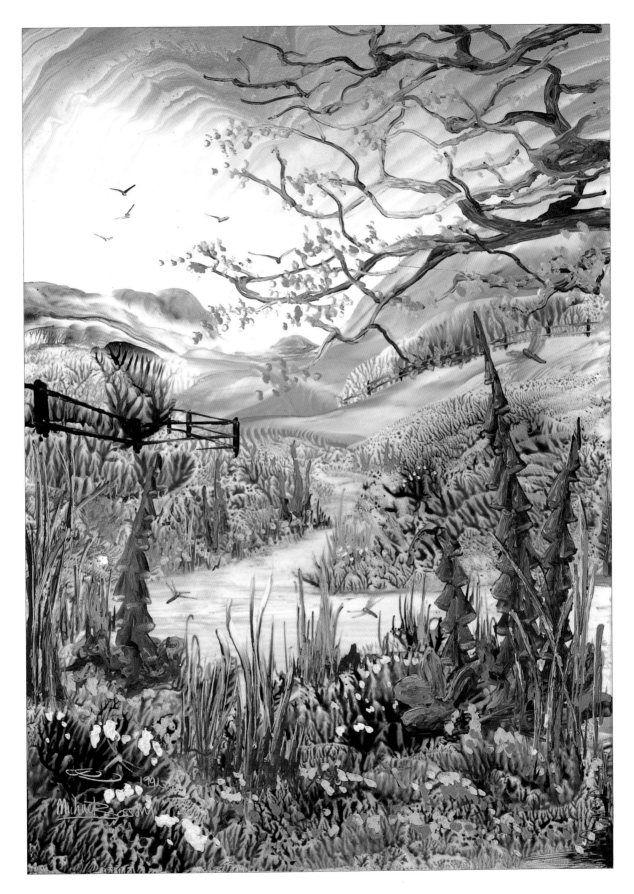

Colour harmony

Colour harmony unifies the image and adds a realistic feel to the illusion.
On these pages I have produced four images of similar construction but all
with completely different colour schemes.

The original landscape, painted with my choice of natural colours.

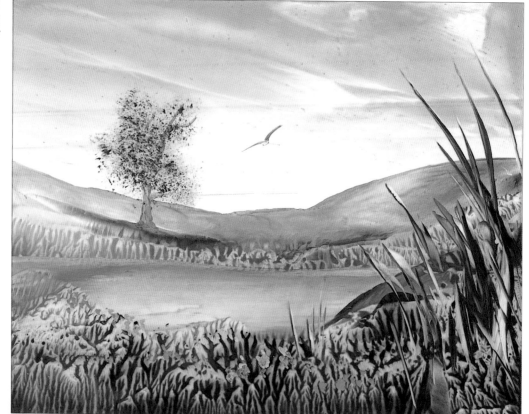

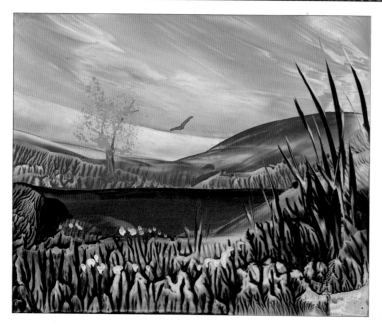

A blue sky and green fields, as in the scene above, are accepted as realistic whereas the green sky with blue fields are considered much less so. Disunion of colour tends to break an image into sections that have little in common. The result is an unconvincing, unrealistic image.

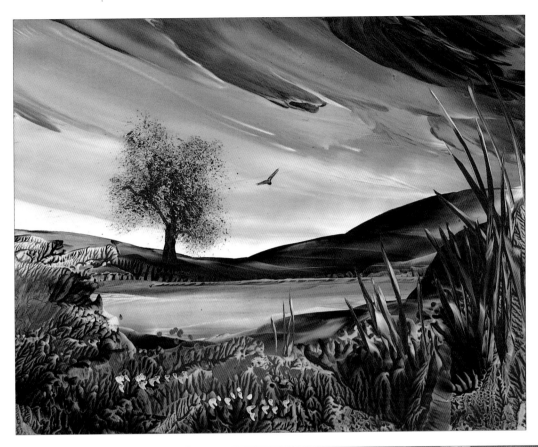

By altering the colour scheme you can change the mood of the scene. Here, a harmonised range of yellows, oranges, browns and black turns the image into a moody sunset.

Unusual colour combinations can be employed in fantasy art. In this example I made subtle changes to the detail: the tree became a fantasy castle, the bird a dragon and the grasses brambles.

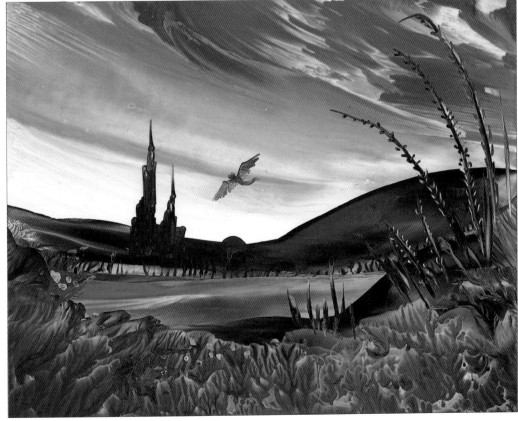

Fantasyscapes

Fantasy is the imagination unrestricted by reality – alien forms and colours are allowed and accepted and the weird and wonderful can be embraced. Molten wax colours can create fascinating effects, and these should encourage your imagination to develop.

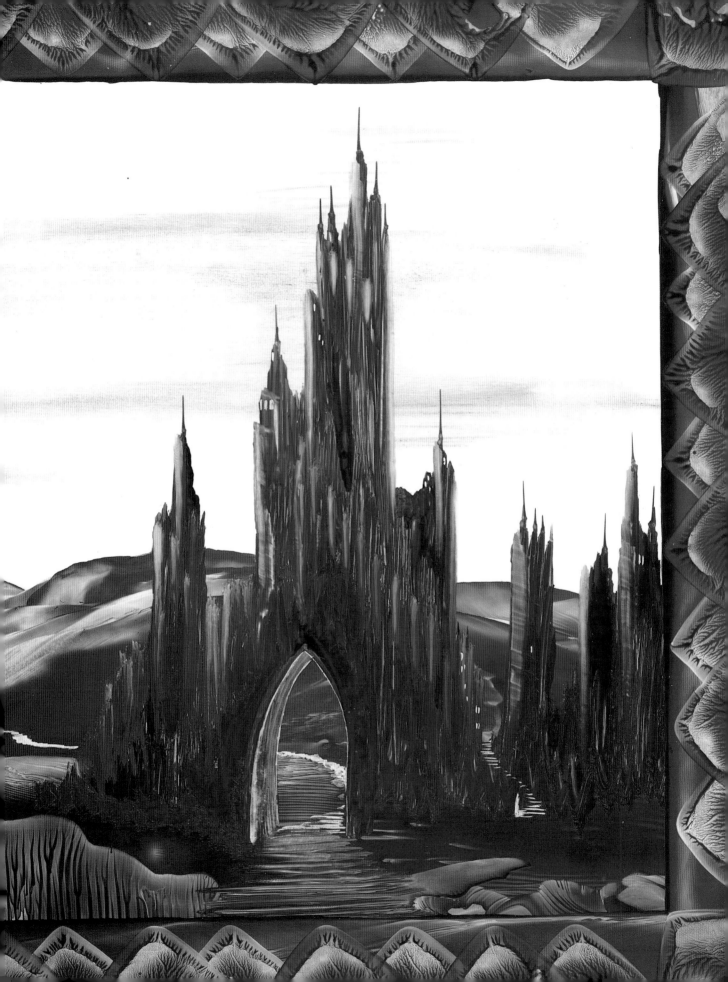

Elements of fantasy

You can transform a basic landscape by using bright, vivid colours and adding castles, planets and fantastic creatures.

Castles are very easy to create. Mine are based on a series of straight lines that run parallel to the edge of the card.

Aim to position your castle somewhere in the middle foreground where the wax colour is strong and dark. Work the foundation into this area using the same colour as the background so that the join is invisible. Now, using the tip of the iron or the pointed stylus tool, scribble a series of joined lines up from the base to form a vertical block. Take up more colour and scribble a slightly narrower block on top of the first. Continue, until you have built up your castle. Create sharp spires with a flicking action from the top of the castle. Scratch away some of the wax to make a few windows.

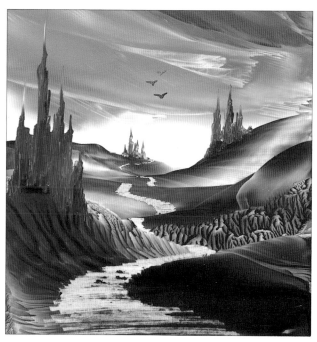

For a planet, use the hot brush-head stylus and work inside a simple stencil to keep the shape perfectly round.

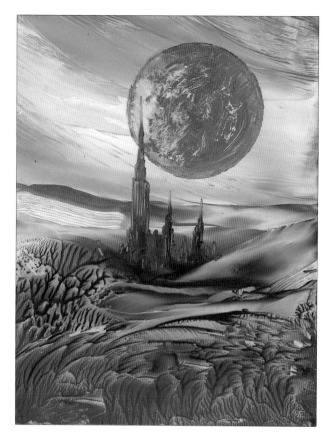

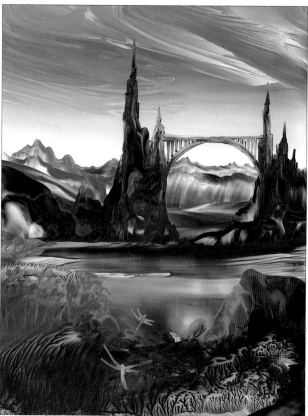

Scry effects

The verb *to scry* means to divine (as in crystal gazing). Working with encaustic wax certainly helps develop imaginative vision. As you paint you may see shapes emerge and then dissolve back into the wax. You can exploit these by using a scraping tool to work the shapes into the background.

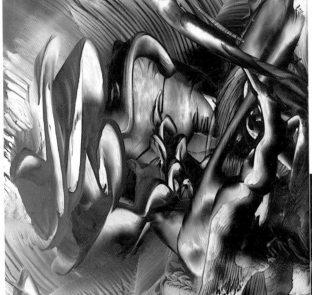

Here are a couple of abstract background images. What can you see in them? An under-water reef, figures, animals, plants, a forest? Or do they just appear to be some coloured wax on a bit of card?

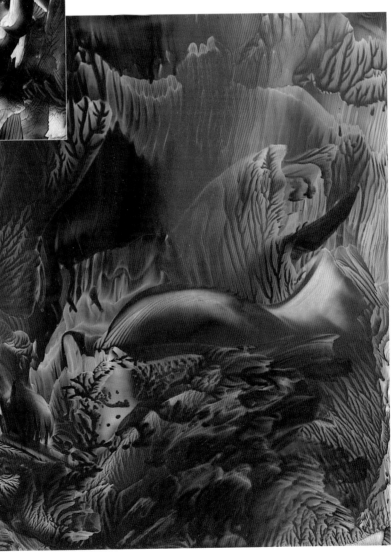

Creating backgrounds

Any abstract background can be used to scry into. By developing the basic smoothing technique you can produce some very interesting backgrounds. Choose a combination of three complementary colours and load them on the iron in five bands. Use plenty of wax and cover the whole of the baseplate.

1. Place the iron on top of the card, close to and parallel to one of the short sides. Gently smooth the iron sideways along the full length of the card; the iron should almost float on the wax as it moves. The separate bands of colour will blend at their edges, but they should still be clearly distinct.

2. Repeat the action, keeping the whole width of the iron in even contact with the card. Move the iron slowly and lightly, sliding it right off the end of the card. If you find that you have scraped off most of the wax, you are pressing too hard on the back edge of the iron. Look carefully at the effects left behind in the wax, as this technique often produces patches of light that could resemble castles and caves. If the effects suggest nothing, repeat until something appears.

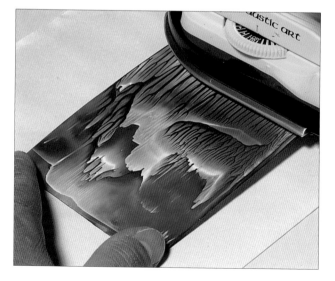

3. More dramatic effects can be achieved with a dragging technique. This is a variation of the smoothing action where the iron is held at an angle to the surface of the card, with the trailing edge 3mm ($^1/_8$in) above the surface.

Lay down a background as in step 1 and then immediately replace the iron at the start position. Holding the edge of the card with your free hand, raise the back edge of the iron and slowly start another stroke across the card without using any downward pressure. As you move across the card, pull the iron up slightly, like an aeroplane taking off at a gentle angle. The whole process must be executed as one fluid movement.

In this example of a scry picture, the background effect was created using just the smoothing actions shown in steps 1 and 2. This generated two main areas of light, which I turned into two castles, using a scraper tool. I then joined them together with a bridge.

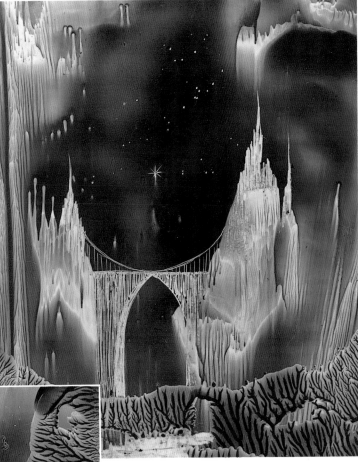

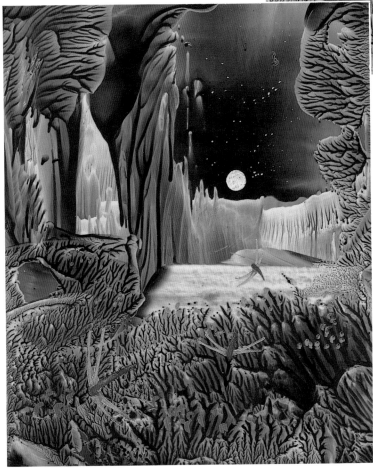

Here I used a single pass of the dragging technique (step 3) to create the rich texture in the upper half of the picture. It inspired a moonlit scene into which I used a scraper tool to draw in the moon and stars, and the pointed stylus to produce the flowers and dragonflies.

Silhouettes and rubber stamps

You can use silhouettes, rubber stamps, tracings and computer clipart to add detail to your abstract images. The technique is a very simple one, but it can produce some interesting pictures.

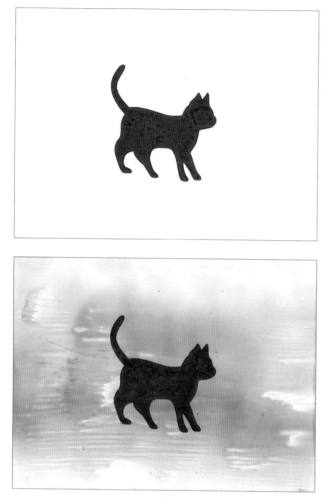

1. Apply the graphic image on to your painting card. Print rubber stamps with a quick-drying ink; finish tracings with a spirit-based permanent marker; print clipart straight on to the card; or simply draw an outline and fill it in, again with a permanent marker.

2. Melt lots of clear wax on the iron. Add a small amount of colour and then use the basic smoothing technique to cover the complete card, including the applied graphic. Avoid using white or any opaque pastel colours. Opaque pigments do not let light pass through them and will tend to hide the graphic. Always use clear wax medium to dilute strong colours. Translucent pigments allow light to pass through them, but they may still need to be weakened.

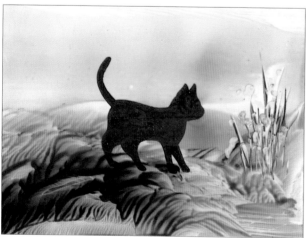

3. Although it is usual to apply the graphic before you add the wax, if you use a good quality marker, it is possible to add details on top of the wax. To make the final image look more accomplished, use the stylus to work in more coloured detail on top of the background wax.

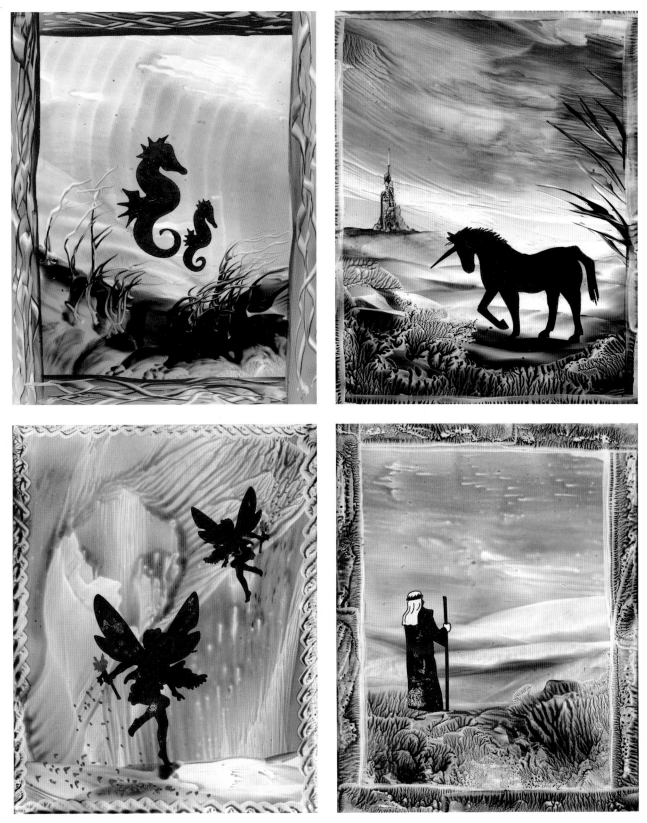

Fairies, fish, butterflies and birds are easy subjects as they all enjoy airy or watery environments. Careful thought must be given to placing an image (like the unicorn above) that needs a defined environment.

Wax transfer techniques

Up until now we have applied wax directly from the iron on to painting cards. However, you can get very different effects using indirect wax transfer. This technique involves applying wax colours on to tissue paper and then using the iron to push the wax through the tissue down on to the card. You can transfer a painted image from a card on to fabric.

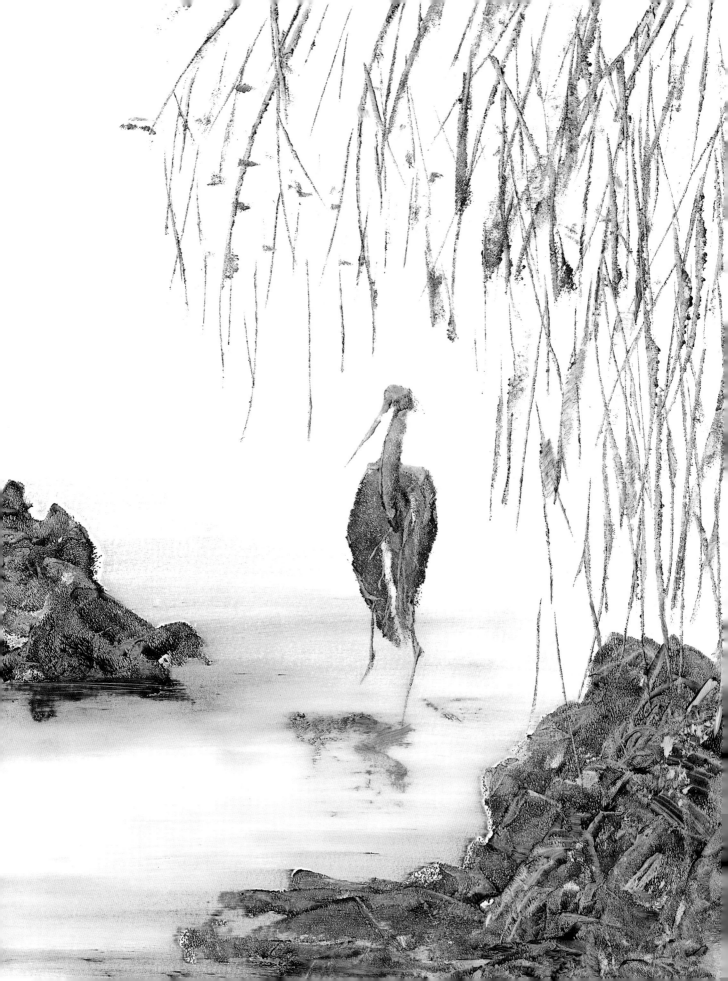

Indirect wax transfer

This technique involves making a palette of colours on some tissue and then using the iron to transfer the wax on to the card. The tissue used for this technique must be soft, relatively strong and absorbent – two-ply tissue is ideal.

Loading the tissue

Melt one wax colour on to the iron and then wipe it off in a small area of an opened-out tissue. Repeat with a second colour, slightly overlapping the first, and then with a third colour over the other two When you come to lift the tissue, if it sticks to the underpaper, replace the iron to melt the wax again. The impregnated tissue will last for several pictures and more wax colour can be added as it becomes depleted. Tear round the edges of the waxed area and discard the rest of the tissue.

Applying the wax

Lay the coloured transfer tissue on top of a painting card with the waxed side of the tissue face down. Place the tip of the iron on to the tissue with the back of the iron raised about 25mm (1in). Move the tip in small vigorous strokes, pressing down quite hard to force the wax out of the tissue and on to the card. Different shaped strokes will of course give different results. You can peep under the tissue without lifting it off the card to check that the application is working and see how the image is developing.

Rocks in water

On a new card, apply small vigorous strokes in two areas to make the piles of rocks. Try to get some blue colour at the bottom of these areas. Now, press your finger down on to the base of one of the rock formations and rub it horizontally until the colour starts to smear and appear waterlike. If the wax is too dark after rubbing, remove some by wiping it off with a clean tissue. Try using various types of stroke actions to discover different effects – stones, boulder, walls etc.

Grasses

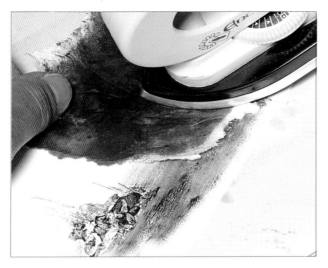

Carefully position the transfer tissue over the area where you want to add some grasses. Make these with the edge of the iron as normal, but working slowly through the waxed tissue.

Dragonflies

Finally, apply a couple of dragonflies with the pointed tool. The tip of the iron can be used if held carefully as shown on page 39.

The finished picture, created using the indirect transfer method.

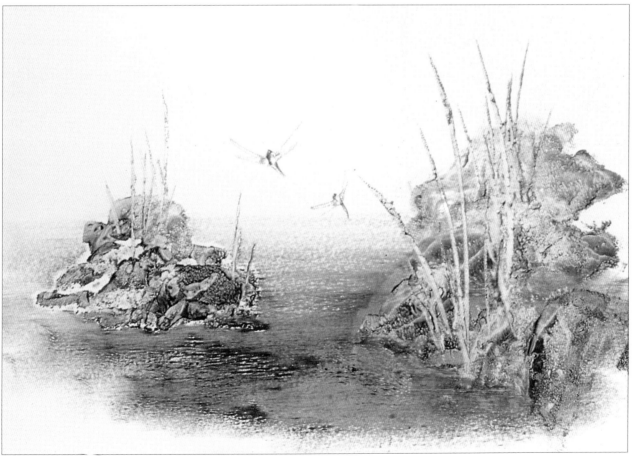

Transferring images on to fabric

Wax images can be transferred off of the non-absorbent painting card on to fabric. This creative technique is a wonderful starting point for decorative items: pictures, wallhangings, collage etc. However, it is not suitable for contact fabrics such as clothing and furnishings.

You can use most types of fabric. Silk-like fabrics, with fine weaves do work best but even rough materials, such as aida canvas, will absorb enough wax to give a strong undefined structure for development with embroidery. A fine, robust polycotton material is good for general embroidery, but experiment with whatever you have to hand.

First paint an image on to a piece of card, using slightly more wax than normal to form a good thick coating on the card. This practice ensures that the image becomes liquid enough when remelted to make a good transfer print. If necessary, you can crayon over the whole image with clear wax medium to build up the wax layer on the card, but be careful not to press too hard, or you will wear away the painted image.

On a clean sheet of underpaper, place some opened-out sheets of tissue, the fabric (face up), the wax painting (face down) and finally, some more opened-out sheets of tissue. Set the iron at a

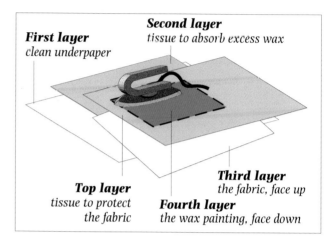

First layer
clean underpaper

Second layer
tissue to absorb excess wax

Top layer
tissue to protect the fabric

Third layer
the fabric, face up

Fourth layer
the wax painting, face down

medium setting (slightly hotter than for painting) and work it slowly and firmly all over the back of the painting card. You can hold one side of the card down and partially lift the other side to check the transfer of wax. When you are happy, remove the card from the fabric while the card is still warm.

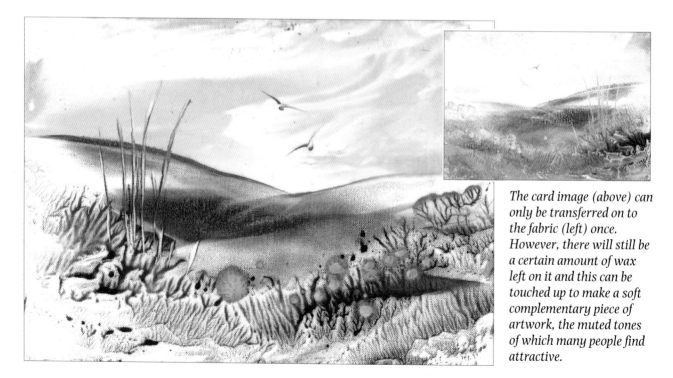

The card image (above) can only be transferred on to the fabric (left) once. However, there will still be a certain amount of wax left on it and this can be touched up to make a soft complementary piece of artwork, the muted tones of which many people find attractive.

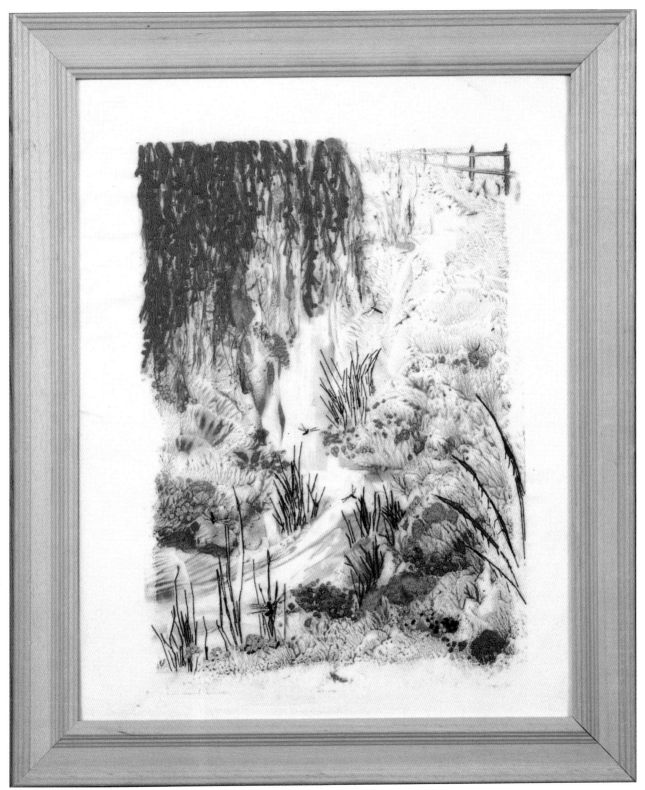

Flowers by the waterfall
This is a lovely example of an embroidered encaustic transfer print, created by Jane Champion.

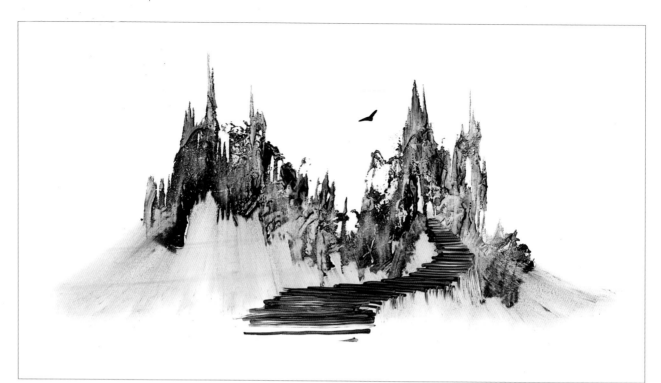

The mountain temple

This indirect wax transfer picture was made by vigorously sawing the edge of the iron up and down. I started at the left-hand side and worked across the card. I used my finger to create the lower slopes of the mountains, and a pointed stylus to draw in the path up to the temple and the other small details.

Index